目錄

既遠又近

前言・結論

生活中的戰爭形式不一定有槍帶砲聲，隨時隨地都可能會發生；

珍愛家園。

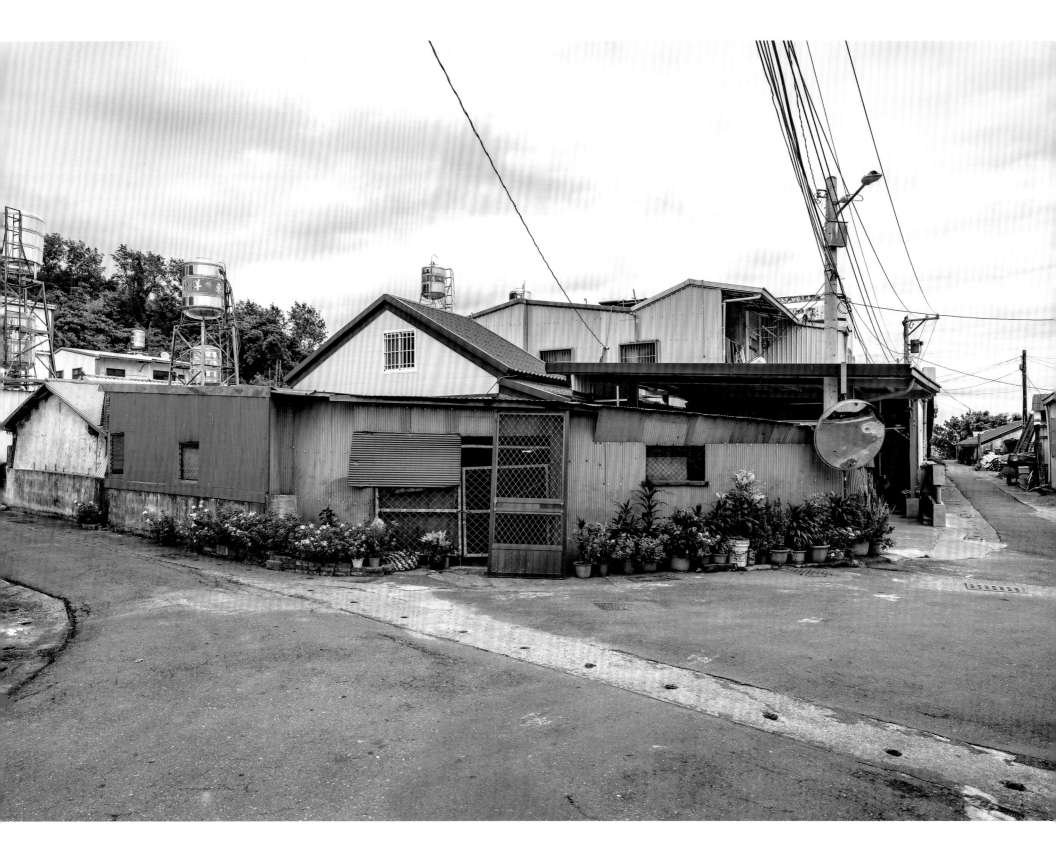

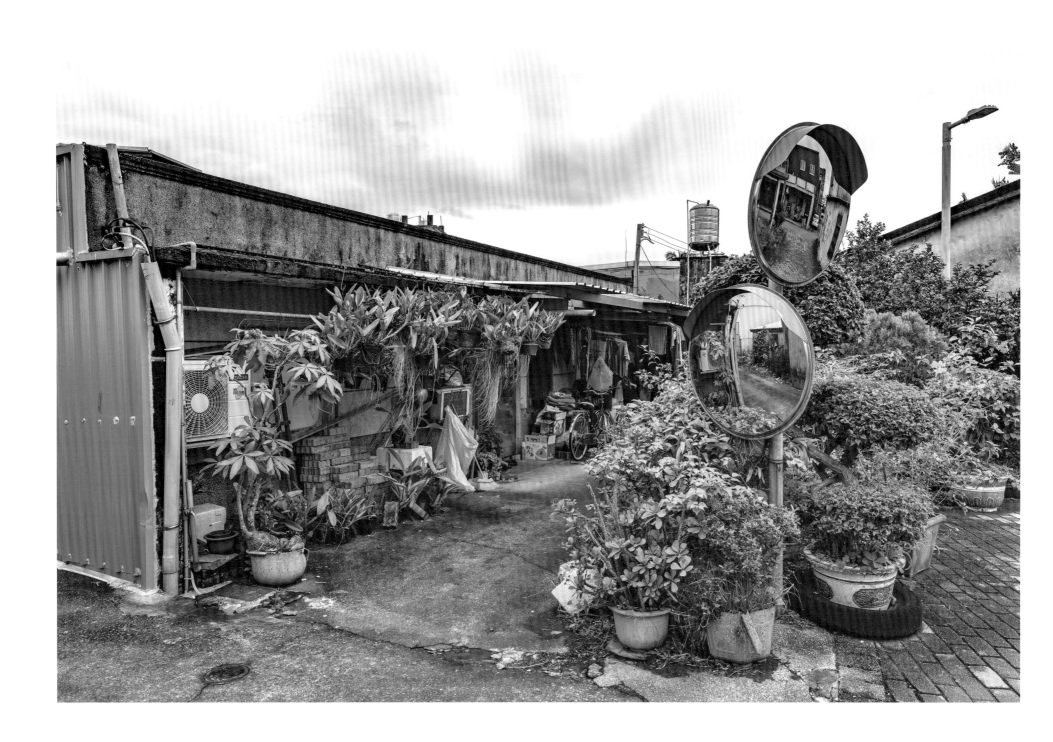

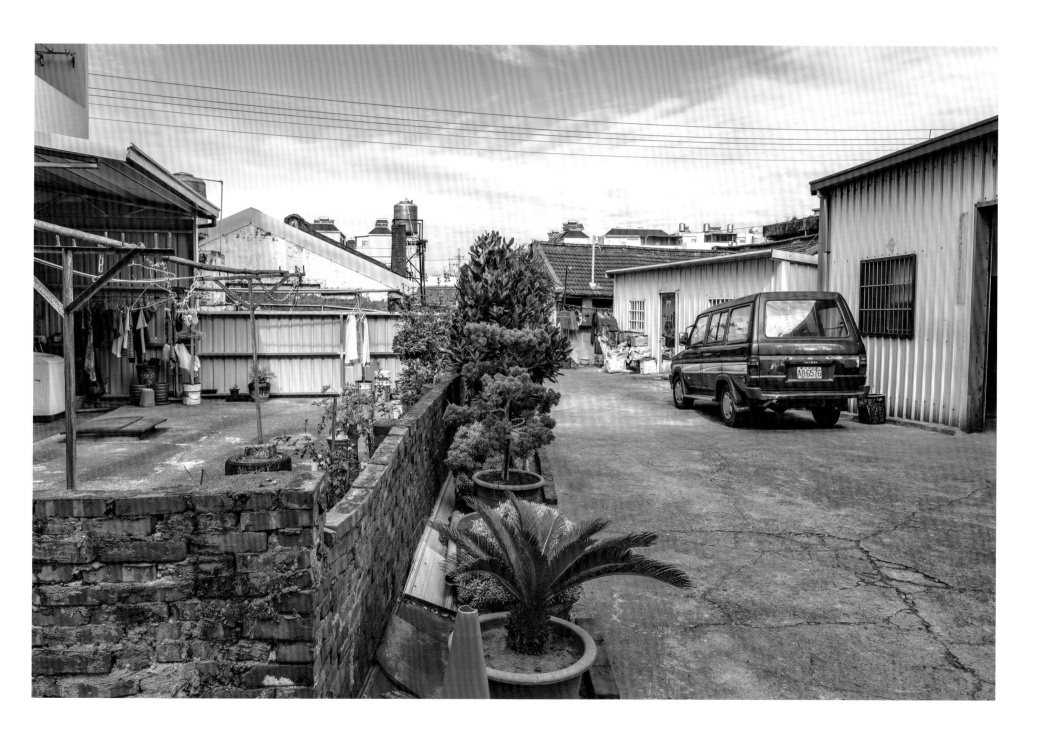

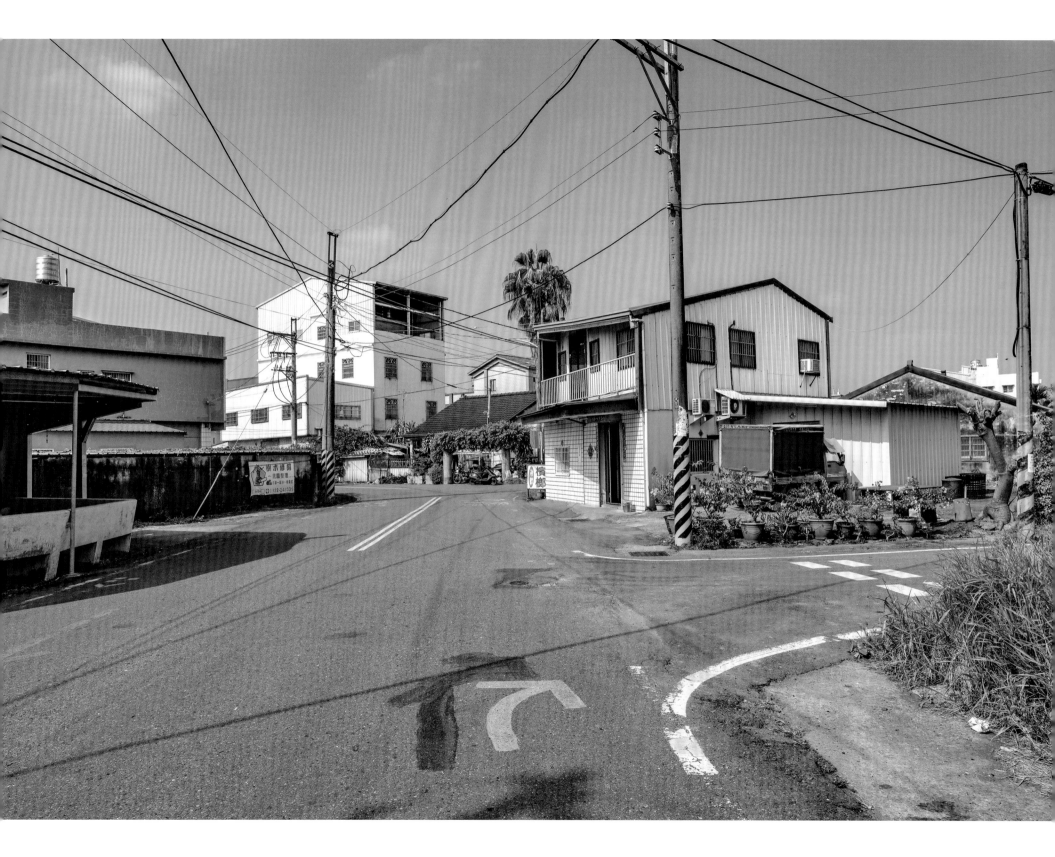

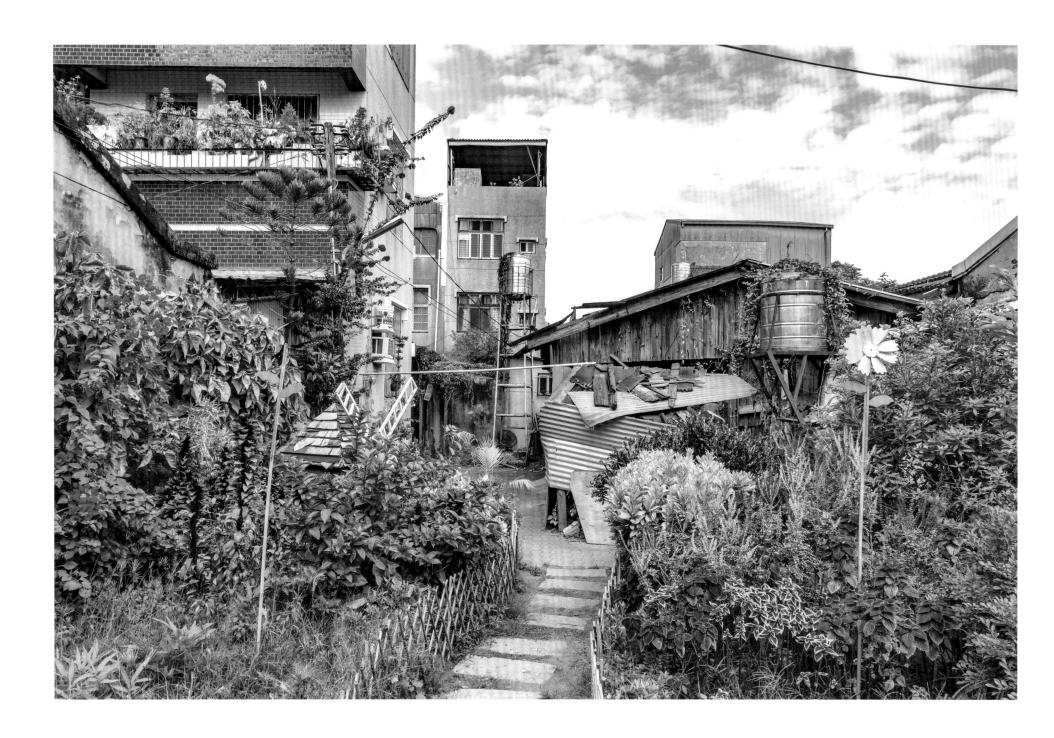

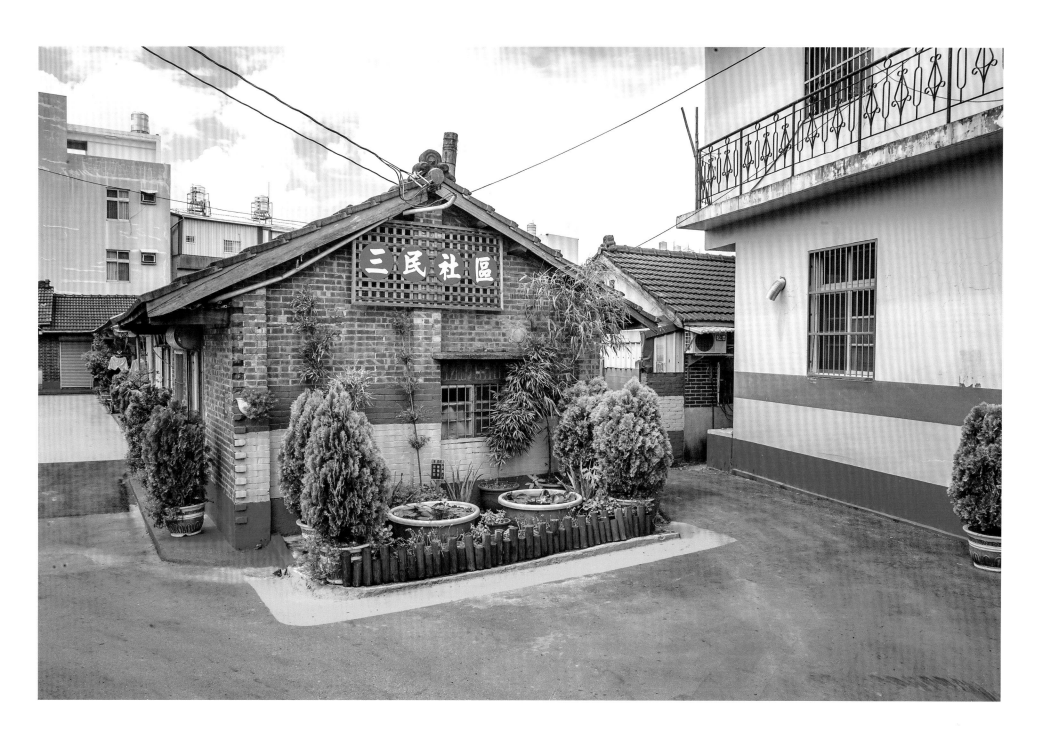

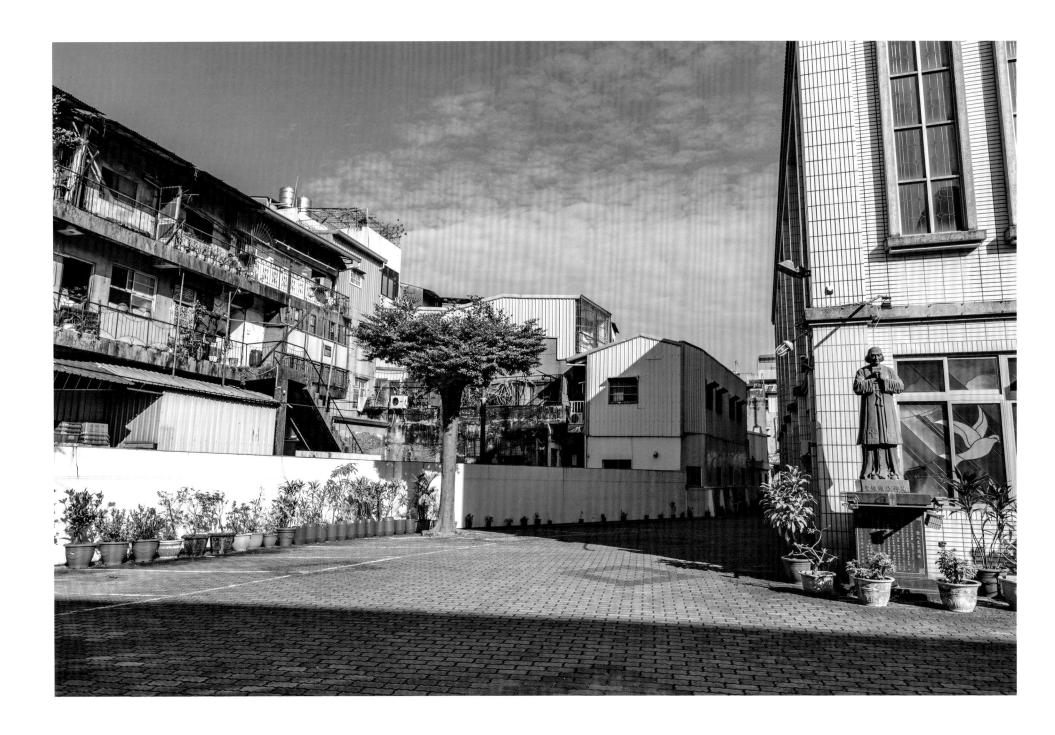

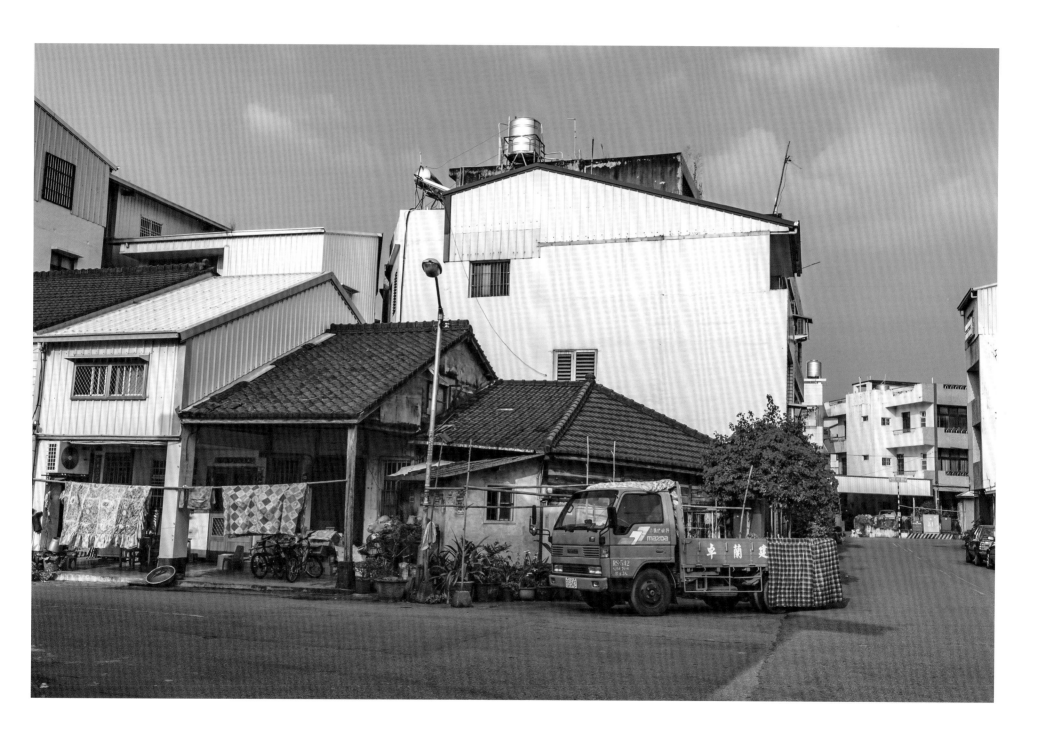

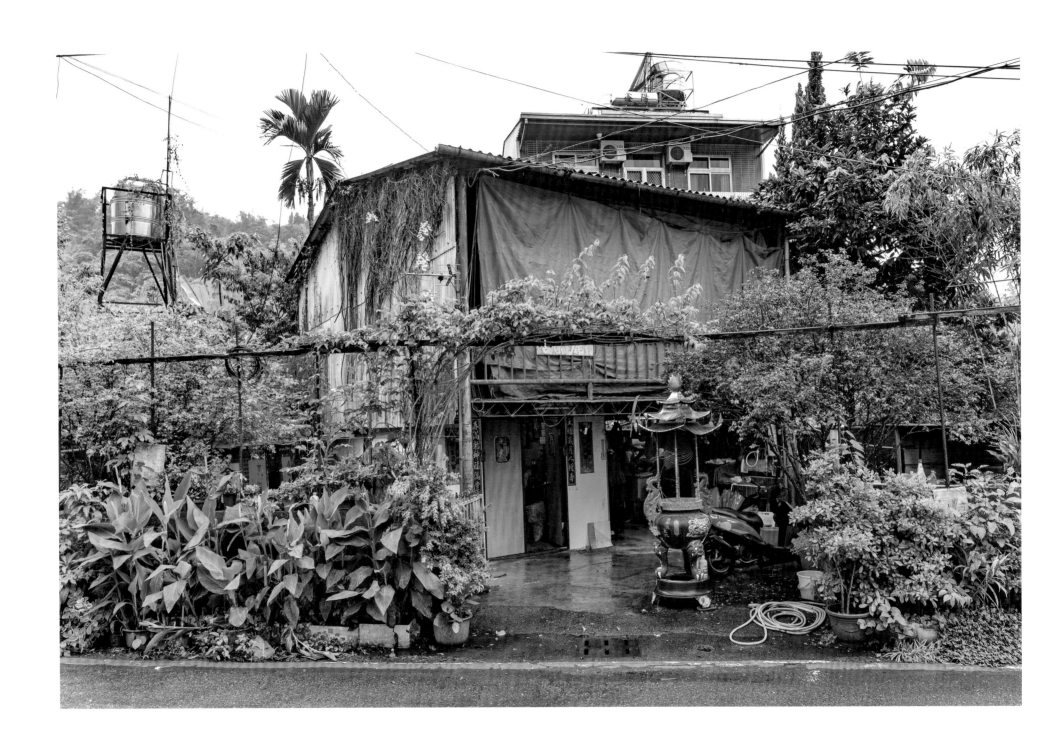

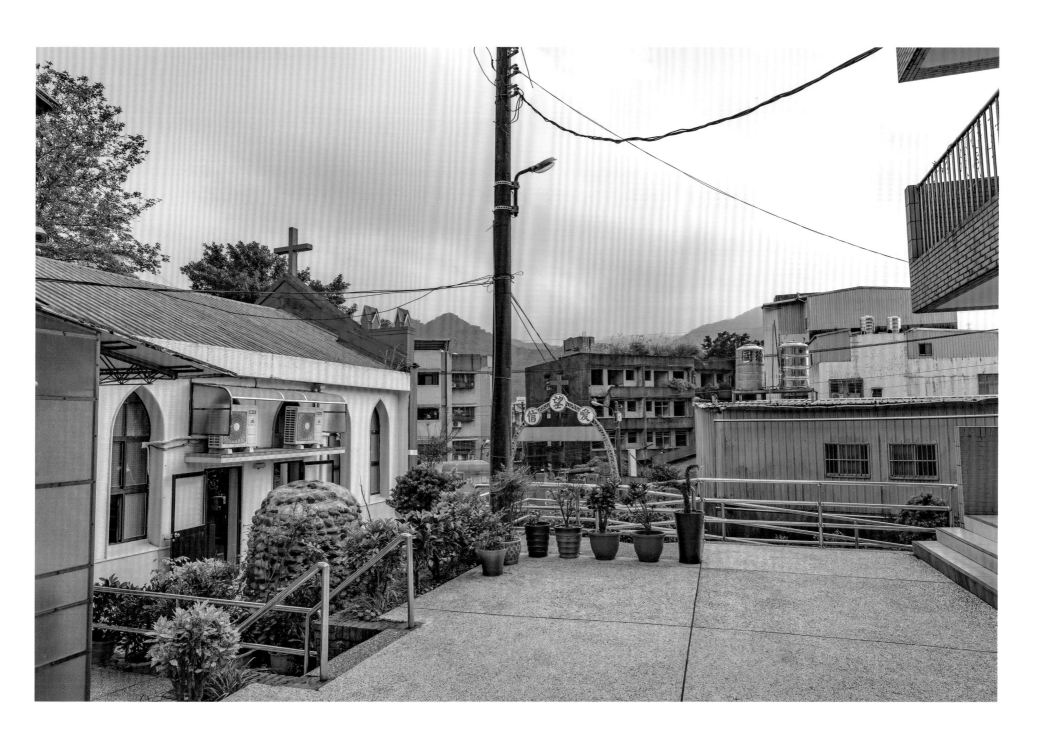

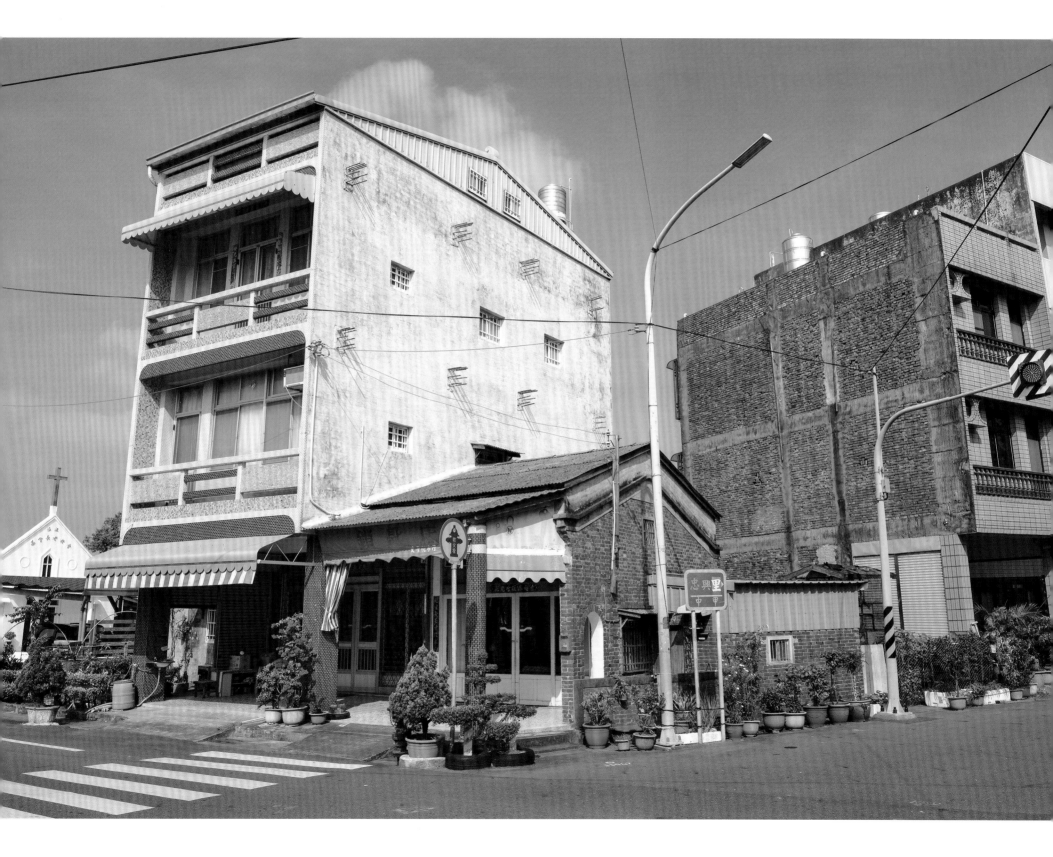

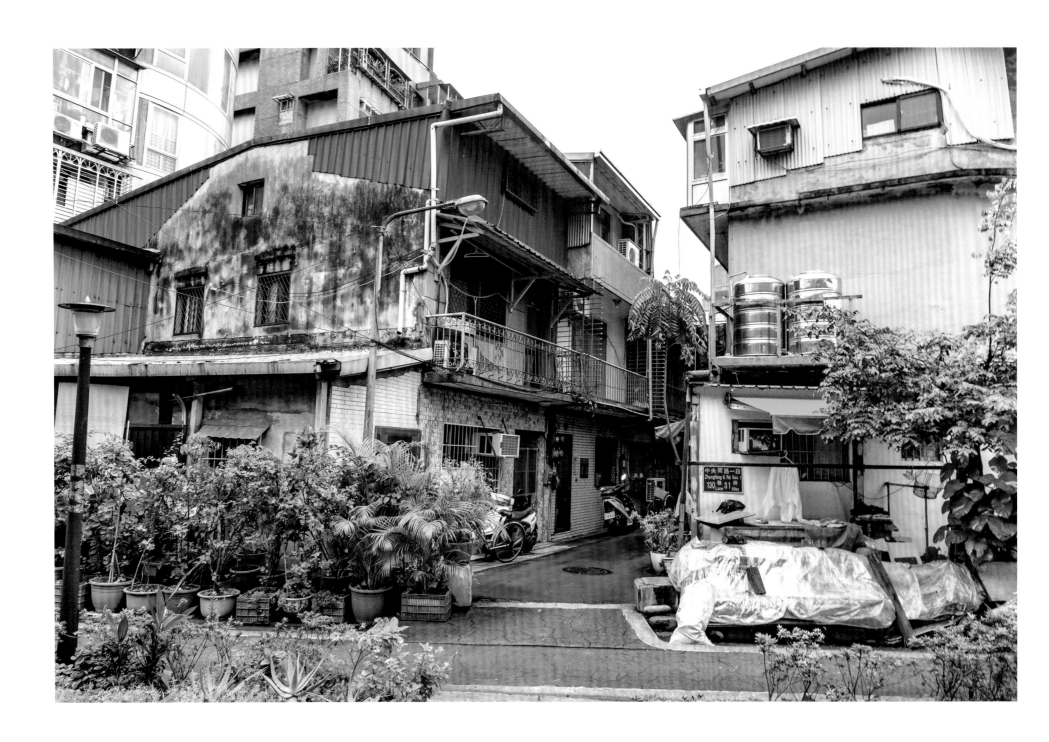

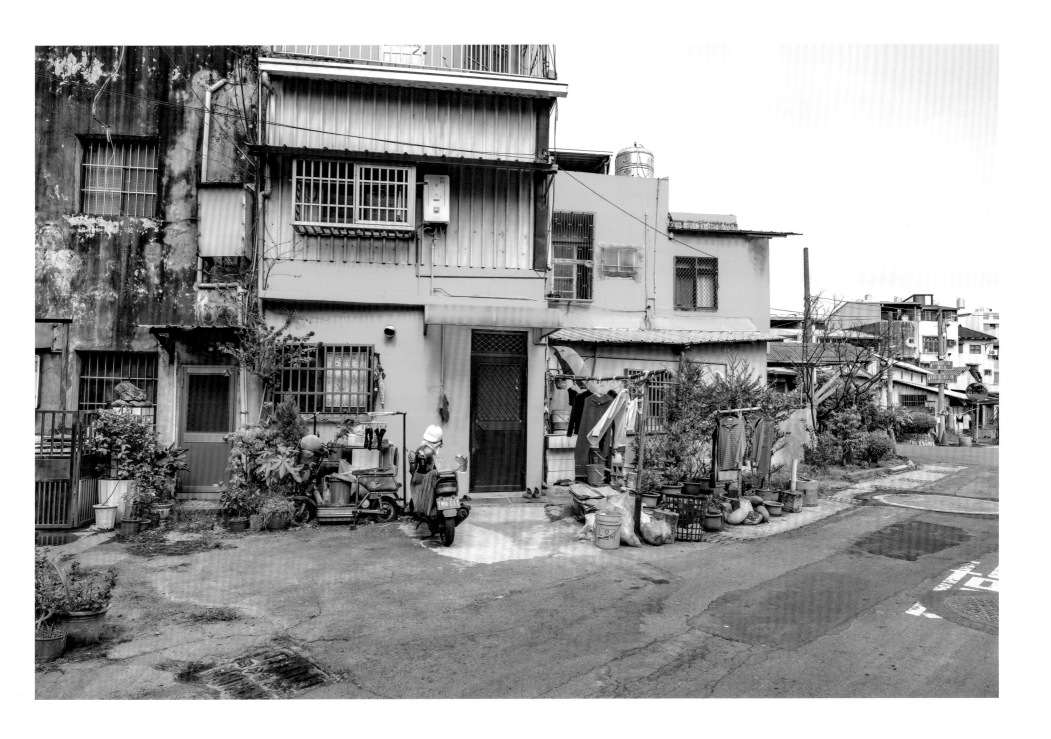

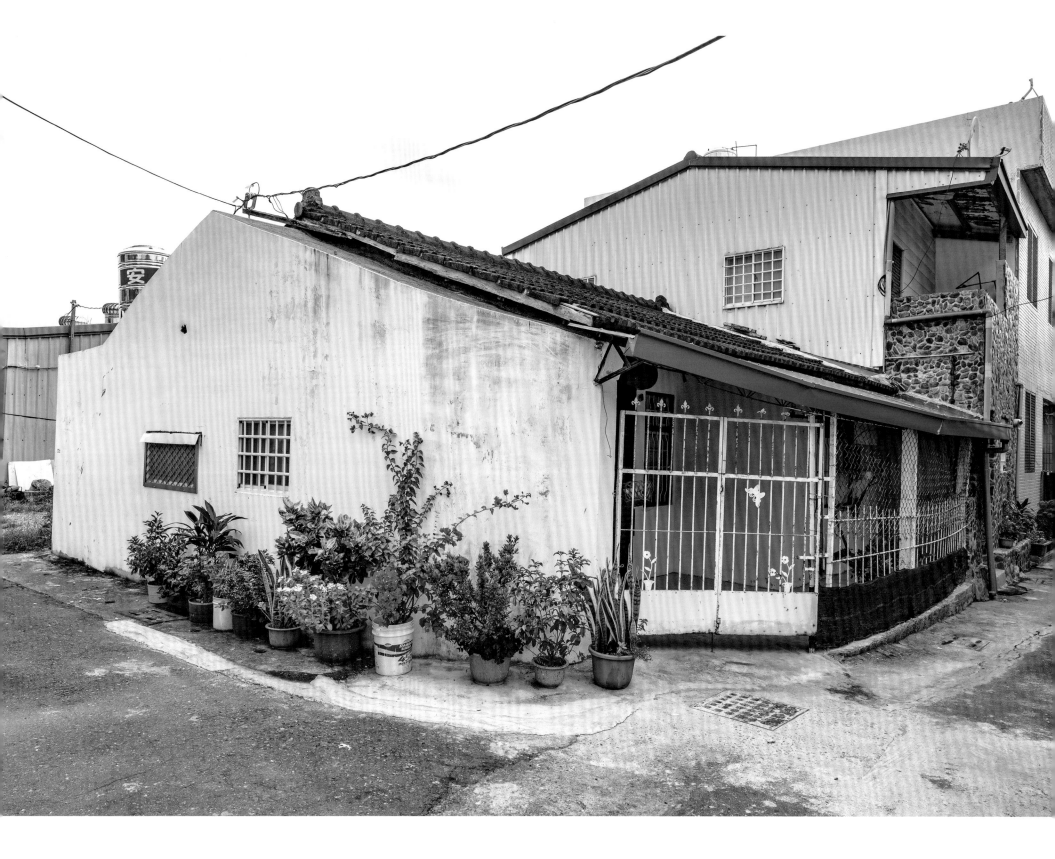

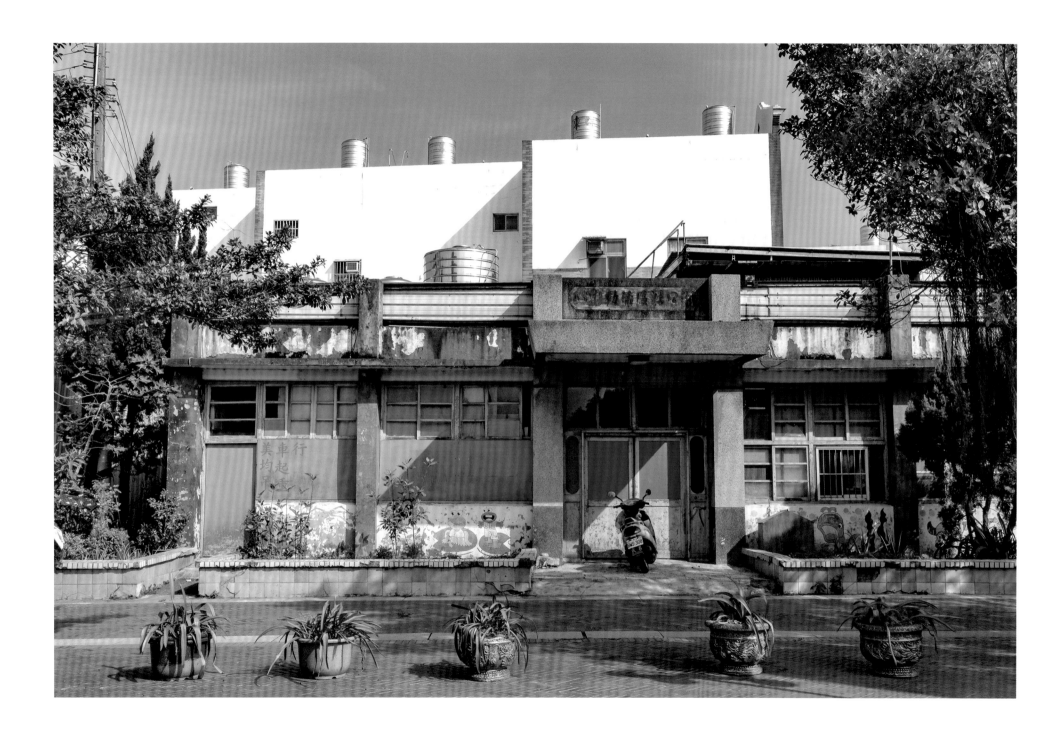

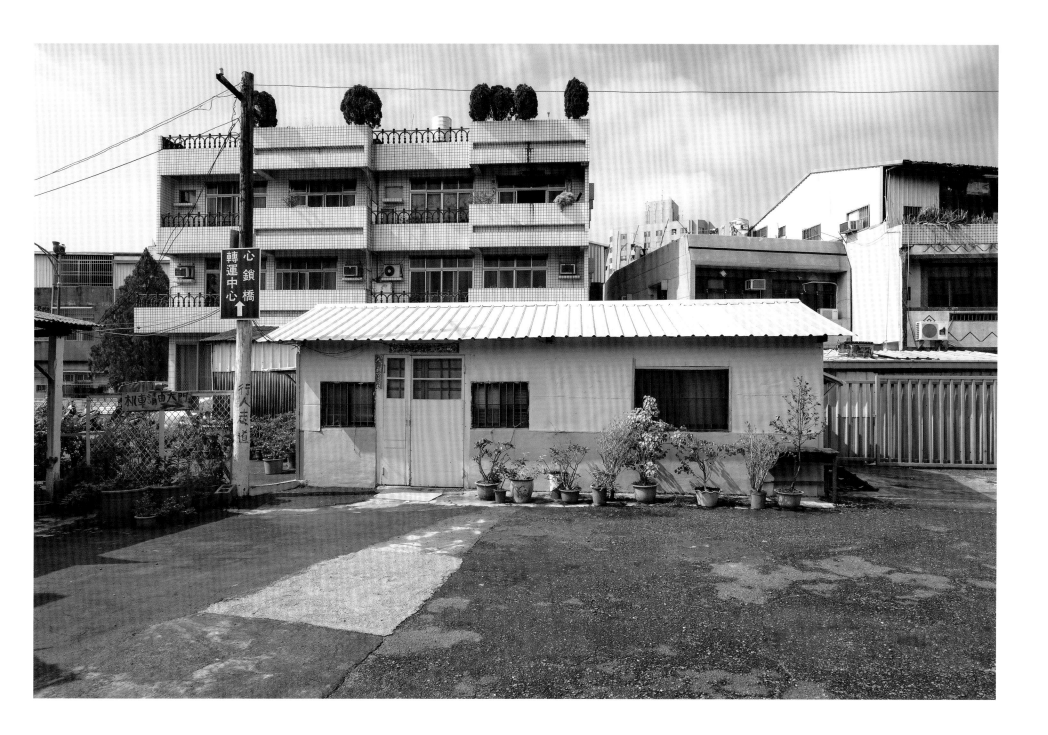

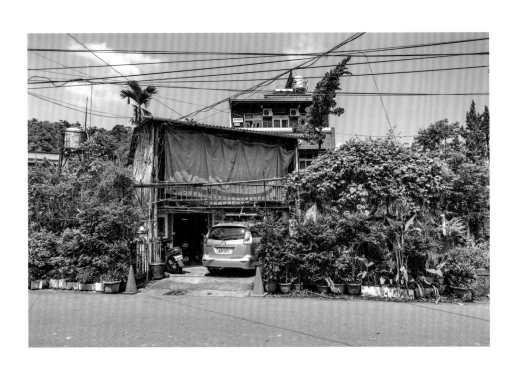
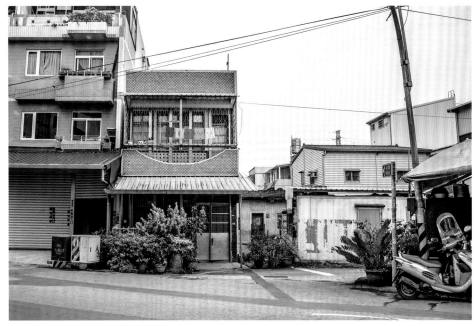

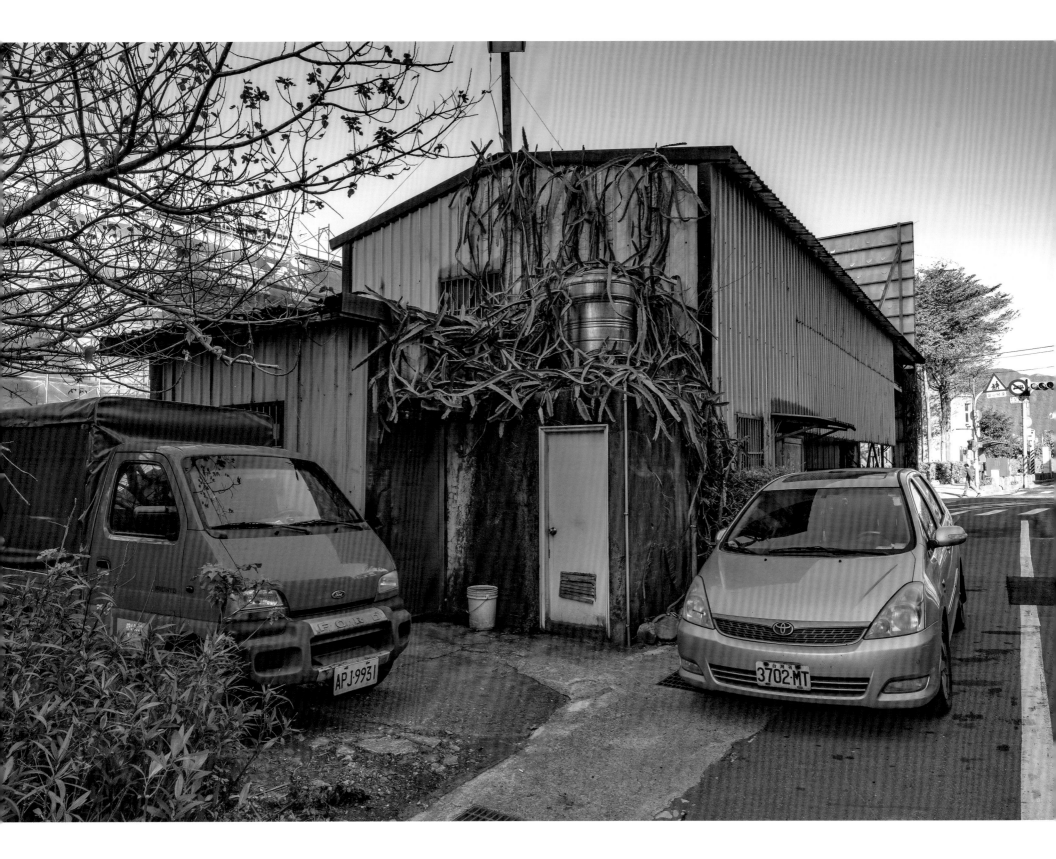

炎熱的夏天，美人千里迢迢順道夜遊台灣

很多人生氣了！敵對，不再是假想的情境、可以協商的對象

隔天傍晚，前後不到 20 個小時，美人乘坐同一班飛機走了

敵人變臉了！真演習 72 小時，展示近來的海空模式

敵人咆哮了！包圍、缺油、斷你糧，更新對海、對人的白皮書

看你怕不怕？

……

疫情接二連三，全球性的通膨不限遠近；無人機、不對稱戰爭、洲際導彈，聽起來都有莫名的興奮感；正義——不需要翻譯的外交辭令；同盟——國與國之間利害關係的短暫……

年初以來的烏俄戰爭，全球的小國家多少都認知到：國防近在咫尺，經濟挑戰無時無刻；即使沒有實質的介入戰爭，購買優良武器的事可以提早交給軍人，但和國家存亡的網路訊息又要如何判定真假？百姓還不到存糧的生死關頭，一旦有事，自家人的基本物資又應該如何調配？——茫然無解的瞬間。

實體的軍事戰看似遙遠，經濟的困境已是當下。全球新聞持續報導，歐美專家紛紛揣測，北歐烏克蘭的區域戰爭「＝」遠東地區的台灣。電視機前，老伯伯笑著說：從今而後，老外不會再搞不清楚台灣的英文（Taiwan）和泰國的（Thailand）了！一旁，念高中的小孩問：我們要不要居安思危？老伯伯的血壓頓時升高，雙手抱胸的說：生命、生活中任何形式的戰爭，政治、經濟、軍事、資訊、愛情、宗教信仰、減肥、節食……要自衛、想投降、跪求和，還得自問有沒有本事？小孩再問：未雨綢繆需要教育或實習嗎？

民主島上的居民對海峽危機的意識，就算是早在烏俄戰爭之前，但仍然舉手發問：將來我們自救方式的設計中，是否也可以仿效極權社會對民族主義的操弄？政客支支吾吾：保家衛國不是少數人的職業，面對外侵（理論上）人人有責……

藝術家「教師」說：即使不以實體的戰事為前提，作品如果可以讓觀眾感悟到，我們因為珍愛自己周遭的對象，想要把它（們）留給自己，或者是將來有機會轉送他人，如此「愛」和「惜」的心態，就可以是群體對於「文化、藝術心理建設」的基礎。

有心的攝影家舉起相機說：我可以用自身民主的涵養、有感文化照像的藝術，透過「水塔造像」和「家園照像」的模式來替代槍砲，以心理的精神建設來抗拒外來的侵略。

《既遠又近……》
單一的水塔：防患未然的孤軍奮鬥
三五成群的水塔：天有不測風雲的集體演繹

「水塔造像」

台灣的水塔分布大小鄉鎮，和民眾日常貼切的現象，媲美玉山的台灣形象。

有水塔的台灣造像《既遠又近……》，以「風」的圖象，隱喻島上長年飽受大自然的颱風，以及近代多方外來客侵台的歷史；分岔路口的家園照像，表徵台灣處於地緣政治「風暴中心」的現況；透過鏡頭在大自然、生活裡，製造出帶有警示意味「Ｘ」形狀的「藝術性社會符號」，藉此提出：身處詭譎多變的時代，是應該經常有站在岔路口的警覺性、是應該多想想，過度安逸的日常，恐怕難以應對人有旦夕禍福的生活酷實。

《既遠又近……》 處處可見水塔的台灣景象表述：

水塔儲水──未雨綢繆的個體認知；

民眾勤於照顧自家附近的花草樹木──愛、惜信念的群體共識。

「家園照像」

放下尋覓好風光的苦心——照像
走進有人生活的街巷——放心
貧富不均的民宅、興隆不一的商家、信仰各異的宗教建物，東張西望——開心
眼見數不盡附屬建物的園地——動心

台灣大街小巷裡，住家外牆邊，交叉路口的三角地，公、私模糊的空間，處處可見自發性的盆、景安置。小小園地，植物不長在地表面上，盆栽形式廣受歡迎。不知名的花，大大小小，不修的綠樹，高高低低，缺角的盆，不見枯枝垂瓣。園子裡，花花草草的健康狀況不一，不礙主人「自動性」排組的自信，植物帥氣輻射著右舍左鄰。

民宅前院，一長排的矮花小樹，客氣標示了水泥地面所有權的範圍，看似楚河漢界的「線狀」家園，圍地不圈人，白天君子跨腳即過，夜裡更不阻小人通行。
花宅從廢棄的保麗龍盒子開始，形貌相似塑膠材質的樹屋，
體積不大——方便挪動
便宜——不擔心被順手牽羊
兼具阻擋外車隨意的停泊

妙！

私有佳物不藏私的家園，公享不獨賞的氣度，發散個人定點視覺的內涵，關照陌生人路過的感受，映現了台灣景色的好，不在捷運、高架橋的豎起，也不在建物更迭的急速變動、滄海桑田對天際線持續的演化。

有好人的台灣風景「＝」人所製造出的好風景。

聚落裡的水塔，平視、俯瞰眼前民主自由、多樣自信的生活美與哲學，大不同於極權制度：由上而下、群眾口號和行動的一致，莫名仇恨、宣洩心盲般的排外民族主義。

游本寬 2022 年夏末

On a scorching summer night, an American lady arrived in Taiwan.

Her visit irritated many. Hostility between two opponents was no longer an assumption, and was no longer negotiable.

Around nightfall the next day, she took off with the same aircraft; her stopover in Taiwan was less than 20 hours.

Following her visit were 72-hour live-fire drills, demonstrating possible military confrontation in the air and in the sea and a besieged energy system with food supplies cut off. White papers outlining more threats are steadily being published while this unfolds.

Are you in awe now?

While the world is suffering from a never ending pandemic and raging inflation, terms ludicrously inciting people arise one after another: drones, asymmetric warfare, intercontinental ballistic missiles, among others. "Justice" has become a word used only in diplomatic language, and an "Ally" suggests nothing but a temporary interest between nations.

Russia's invasion of Ukraine in the beginning of 2022 made many small countries face the fact that national defense is a pressing affair, and economic difficulties are everywhere. Advanced weapons could be handed to the military before a war explodes, but misinformation running rampant on the internet could endanger national security in ways that are hard to address. Although the situation is not so bad that people should start hoarding food now, no one has any idea how to distribute essential materials once a military conflict happens.

While military conflicts may feel remote to us, and economic difficulties are close at hand, news outlets continue to compare Ukraine in eastern Europe with Taiwan in East Asia by quoting experts from the western world. An old man watching TV news laughed, "From now on, people won't confuse Taiwan with Thailand." A high school student asked, "Should we prepare for the worst?" His question agitated the old man, whose blood pressure surged. He crossed his arms in front of his chest and exclaimed, "Lives, war in any form, politics, economy, military, information, love, religion, losing weight, diet… self-defense, surrender, beseeching for peace, all these require certain conditions. Are we qualified?" The youth then pursued, "Do we need to learn or practice planning ahead during crises?"

Islanders might have been aware of the threat across the strait even before the war between Ukraine and Russia began, but questions like this are still raised, "Can we manipulate nationalism, like a dictatorship does, in order to save ourselves from sabotage?" Politicians stammer, "National security is not the occupation of certain groups of people, (theoretically) it is everyone's responsibility…"

An artist as well as a teacher pointed out, "Even though it is not about war, my art means to express to the audience that I want to save the surroundings we love and cherish so much for ourselves or pass them onto others in the future. Our love and cherishment of these things are the essence of collective concern about culture, art and attitudes.

A concerned photographer held up his camera and declared, "With my understanding of democracy and my art, I strengthened my mindset to defend against invasions by taking photos of water towers that symbolize guns and ammunition in homes."

Near and Far…
A single water storage tank symbolizes preparing for the unknown, storage.
Clusters of water storage tanks imply collective actions for an unpredictable future.

Images of Water Tanks

Water storage tanks are seen everywhere in Taiwan, in big cities or in small towns. They are a part of people's everyday lives, and to me, their significance could be compared to the iconic landscape of Jade Mountain. Near and Far… a photography portfolio of water storage tanks in Taiwan, uses an image of wind as a metaphor for this island being threatened by invasions of typhoons as well as foreign powers. Homes located at road intersections are my interpretation of homes/Taiwan being in the eye of a storm. Scenes of crossed lines and trees form an X symbolizing danger. By transforming social signs into my art, I'm warning people to stay alert at all times like at a busy intersection.

Being too laid back might result in our inability to handle sudden disasters among a cruel reality.

Near and Far…
Storing water in tanks is an individual choice to plan ahead.
Taking care of vegetation in the neighborhood is a collective consensus of love and cherishment of the environment.

Images of Homes

Taking photos, I suppress a desire to capture spectacular scenery. Walking through the streets and lanes in daily life, I feel very free.

Seeing households of varying wealth or shops negotiating a growing or declining business, and visiting religious buildings of different beliefs, I feel excited. Finding all kinds of structures attached to buildings, I am overwhelmed.

In Taiwan, beside wide roads or narrow alleys, near the exterior walls of households, at triangular lots in forked roads, or over the blurred borders between public and private domains, one sees bonsai or small landscape arrangements. It is a popular style of container gardening where plants are not grown in the earth but rather in pots. A variety of flowers I don't recognize are positioned near tall and short untrimmed trees. There's no evidence of weeping tree branches, cracked pots, and fallen petals seen here. In a garden, plants in good or bad condition are situated according to their owner's preference, rigorously stretching toward their neighbors'territories.

In the front yard of a house, a row of shrubs beside the concrete foundation modestly marks the owner's territory. The boundary doesn't prevent people from stepping over it in the daytime, not to mention at night.

A flower bed made by a styrofoam box and a light and moveable treehouse made of cheap plastic are used to block cars from parking in front of the property. What a clever idea to make blockades from materials that no one is interested in stealing.

Private things are shared, an attitude of generosity, and paying attention to how passersby feel, an expression of care. The intriguing scenes of Taiwan are not the metro or elevated expressways, but the fast-changing landscapes, including the evolution of buildings and skylines.

Nice Taiwanese people create nice Taiwanese landscapes. From water towers in communities to our forward-looking democracy and freedom, we confidently embrace diverse lifestyles, personal aesthetic preferences, and individualist philosophies. This is the opposite of societies under dictatorship in which a supreme power disseminates propaganda and orders, and spreads indiscriminate hatred, blind nationalism, and xenophobia.

Ben K Yu, the end of summer 2022

游本寬，1956 年生，美國俄亥俄大學 MA（藝術教育碩士）、MFA（美術攝影碩士），現任政治大學傳播學院兼任教授。在大專院校從事影像傳播與美學教育逾 30 年，退休前擔任政治大學傳播學院專任教授、特聘教授（2009-12），退休後往返美國、台灣持續教學、創作，作品曾被台北市立美術館、國立臺灣美術館、國家攝影文化中心等機構典藏。

歷年著作：

《游本寬影像構成》－ 1990

《論超現實攝影》－ 1995

《真假之間》－ 2001

《台灣新郎》－ 2002

《美術攝影論思》－ 2003

《手框景・機傳情──政大手機書》－ 2009

《台灣公共藝術──地標篇》－ 2011

《游潛兼巡露──「攝影鏡像」的內觀哲理與並置藝術》－ 2012

《鏡話・臺詞》，我的「限制級」照片－ 2014

《五九老爸的相簿》－ 2015

《「編導式攝影」中的記錄思維》－ 2017

《超越影像「此曾在」的二次死亡》－ 2019

《口罩風景》－ 2020

《招・術》－ 2021

Ben Yu is currently an adjunct professor of visual art at National Chengchi University in Taipei, Taiwan. His books include:

Welcome: The Art of Invitation (2021)

MASKED: SPEECHLESS (2020)

Transcendent Images, The Second Death (2019)

Fabricated and Documentary Photography (2017)

Ben Ba Photo Album (2015)

The Words Around Us: Seeing Without Understanding (2014)

The Latent and the Visible (2012)

Public Art in Taiwan: Landmarks (2011)

Issues of Fine Art Photography (2003)

The Puppet Bridegroom (2002)

Between Real and Unreal: Reading into Taiwan, Part One (2001)

The History of Surrealism In Photography and Its Applications (1995)

Ben Yu Photographic Constructions (1990)

Mr. Yu has exhibited his work internationally in Paris, Berlin, Yokohama, Seoul, Beijing, Shanghai, Philadelphia, New York, and Taiwan. He lives and works in the United States and Taiwan.

照像資料

05- 台東縣太麻里和美村 -2017
06- 宜蘭縣頭城鎮 -2021
07- 台中市沙鹿區 -2021
08- 苗栗縣三義鄉 -2019
09- 雲林縣古坑鄉 -2006
10- 屏東縣南州鄉壽元村 -2021
11- 台南市歸仁區 -2006

13- 雲林縣斗南鎮 -2021
14- 台南市安平區 -2014
15- 北斗鎮田中三民社區 -2008
16- 台南市東區 -2021
17- 苗栗縣卓蘭鎮 -2011
18- 南投縣埔里 -2015
19- 新北市瑞芳鎮四腳亭 -2016

21- 台南市將軍區中興里 -2016
22- 彰化縣員林市 -2021
23- 嘉義縣太保市二林鎮 -2020
24- 苗栗縣三義鄉 -2019
25- 南投縣南投市永興區 -2020
26- 台北市北投區 -2012
27- 彰化縣彰化市 -2019

29- 台東縣太麻里和美村 -2017
30- 新竹縣湖口鄉 -2013
31- 宜蘭縣頭城鎮 -2018

32- 新北市平溪區嶺腳 -2006
33- 苗栗縣三義鄉 -2009
34- 台中龍井鄉新庄 -2008
35- 高雄市仁武區 -2021

37- 新北市萬里區 -2008
38- 苗栗縣後龍鎮 -2017
39- 台南縣關廟鄉新埔村 -2010
40- 苗栗縣通霄鎮白沙屯 -2014
41- 雲林縣西螺鎮 -2007
42- 台南縣關廟鄉新埔村 -2010
43- 新北市瑞芳鎮四腳亭 -2020

45- 台東縣鹿野鄉 -2017
46- 新北市三峽鎮 -2019
47- 彰化縣芬園鄉竹林 -2020
48- 屏東縣潮州 -2006
49- 嘉義市西區鐵道藝術村 -2016
50(L)- 南投縣埔里鎮桃米村 -2019
50(R)- 宜蘭縣宜蘭市 -2009
51- 新北市八里鄉 -2018

1~80 < 大風起 > / State College, PA, USA
1~80 < 前叉路 > / State College, PA, USA

《既遠又近》 Near & Far... 游本寬著 . 初版

臺北市： 游本寬，民 111.10
國家圖書館出版品｜ CIP ｜預行編目資料
ISBN 978-626-01-0597-6（精裝）
80 面；30 x 23 公分
1. CST: 攝影集
958.33 111015665

出版者：游本寬 / Ben Yu
著作權人：游本寬 / Ben Yu
地址：106 台北市大安區建國南路二段 308 巷 12 號 7 樓
電子信箱：benyu527@gmail.com
個人網址：benyuphotoarts.tw

代理經銷：田園城市文化事業有限公司
地址：台北市中山區中山北路二段 72 巷 6 號
Facebook：田園城市生活風格書店
電話：886-2-25319081 ｜傳真 886-2-25319085
讀者服務信箱：gardenct@ms14.hinet.net

印刷：佳信印刷有限公司
地址：新北市中和區橋安街 19 號 3 樓
電話：886-2-22438660
信箱：chiasins@ms37.hinet.net

English Translation by C. J. Andrson-Wu, Steven M. Anderson

出版日期：中華民國 111 年 10 月初版
定價：新台幣 800 元整